D1071125

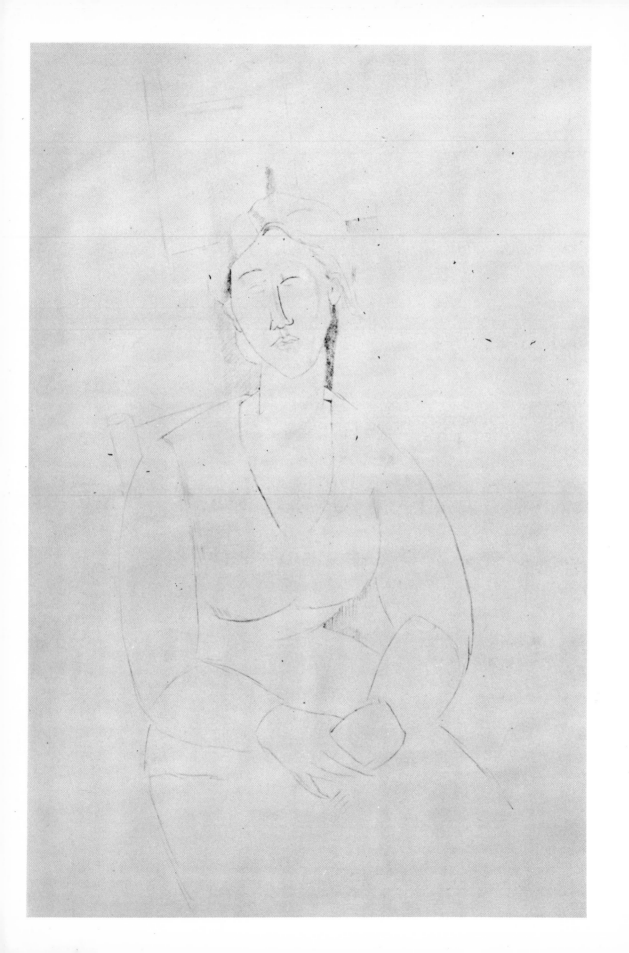

MODIGLIANI

PAINTINGS

DRAWINGS

SCULPTURE

with an introduction by James Thrall Soby

THE MUSEUM OF MODERN ART NEW YORK

IN COLLABORATION WITH THE CLEVELAND MUSEUM OF ART

Reprint Edition 1972

Published for The Museum of Modern Art by Arno Press

Library of Congress Catalog Card Number 73-169318
ISBN 0-405-01576-3
Copyright 1951, The Museum of Modern Art
Printed in the United States of America

ACKNOWLEDGMENTS

On behalf of the President and Trustees of the Museum of Modern Art and of the Cleveland Museum of Art I wish to thank the collectors, museums and dealers whose generosity in lending has made the exhibition possible. The initial preparation for the exhibition was made abroad by William S. Lieberman, Associate Curator of Prints, Museum of Modern Art. Final arrangements were conducted by the staff of the Department of Painting and Sculpture. We are very grateful to Mr. James Thrall Soby for his excellent appreciation of the artist and to Miss Jane Sabersky for her help in assembling the drawings of the artist. Particular thanks are due to the following for assistance in the preparation of the exhibition: Dr. Paul Alexandre, Count Vittorio Emanuele Barbaroux, Henri Bing-Bodmer, James H. Breasted, Jr., Miss Marie-Suzanne Feigel, Dalzell Hatfield, César M. de Hauke, André Lejard, Jacques Lindon, Jacques Lipchitz, Marlborough Fine Art Ltd., London, Pierre Matisse, Giovanni Scheiwiller, J. K. Thannhauser, Romeo Toninelli and Lamberto Vitali.

ANDREW CARNDUFF RITCHIE, *Director, Department of Painting and Sculpture*

LENDERS TO THE EXHIBITION

Dr. Paul Alexandre, Paris; Miss Doris Baker, New York; Mr. and Mrs. Joseph Bissett, New York; Mr. and Mrs. Leigh B. Block, Chicago; Miss Fanny Brice, Los Angeles; Mr. and Mrs. Leon Brillouin, New York; Mrs. Towar Bullard, New York; Ralph M. Coe, Cleveland; Luigi Corbellini, Paris; The Chester Dale Collection; Estate of George Gard DeSylva, Los Angeles; Mrs. Marjorie Fischer, New York; Carlo Frua de Angeli, Milan; Mrs. John W. Garrett, Baltimore; Mr. and Mrs. John Gerald, New York; Dr. Stephen Goodyear, Englewood, N.J.; Prince and Princess Artchil Gourielli, New York; César M. de Hauke, Paris; Ernest S. Heller, New York; Miss Marion G. Hendrie, Cincinnati; M. L. Hermanos, New York; Mr. and Mrs. Alex L. Hillman, New York; Dr. Riccardo Jucker, Milan; Maurice Lefebvre-Foinet, Paris; Mr. and Mrs. Sam A. Lewisohn, New York; Mr. and Mrs. Samuel A. Marx, Chicago; Mr. and Mrs. Francisco Matarazzo Sobrinho, São Paulo, Brazil; Gianni Mattioli, Milan; Dr. and Mrs. Warner Muensterberger, New York; Comm. Adriano Pallini, Milan; Henry Pearlman, New York; Mr. and Mrs. Joseph Pulitzer, Jr., St. Louis; François Reichenbach, Paris; Mr. and Mrs. Bernard J. Reis, New York; Mr. and Mrs. Edward G. Robinson, Beverly Hills; Dr. Alberto Rossi, Milan; Mrs. Paul H. Sampliner, New York; The Earl of Sandwich, Hinchingbrooke, England; Jacques Sarlie, New York; Mr. and Mrs. Sydney M. Shoenberg, Jr., St. Louis; Benjamin Weiss, New York; Mrs. Lloyd Bruce Wescott, Clinton, N.J.; M. Zagajski, New York; Richard S. Zeisler, New York.

Albright Art Gallery, Buffalo; Fogg Art Museum, Cambridge; The Art Institute of Chicago; The Wadsworth Atheneum, Hartford; The Los Angeles County Museum; The Solomon R. Guggenheim Foundation, New York; The Philadelphia Museum of Art; Museum of Art, Rhode Island School of Design, Providence; Museu de Arte, São Paulo, Brazil; The Phillips Gallery, Washington, D.C.; The Norton Gallery and School of Art, West Palm Beach.

Buchholz Gallery, New York; Perls Galleries, New York.

CONTENTS

CHRONOLOGY

1884 Born July 12, Leghorn, Italy. Father banker, family from Rome. Mother, born Marseilles said to have been descendent of Spinosa.

1898 Schooling interrupted by illness; began painting at 14, instructed by local painter Micheli.

1900–1902 Second illness. Convalescence in Southern Italy; later to Rome, Florence and Venice. Intermittent academic training.

1906 To Paris. Early work influenced by style of the 90's — Beardsley, Lautrec, Steinlen.

1908 First exhibited in Paris at *Salon des Indépendants*.

1909 First interest in sculpture, reputedly inspired by Brancusi. Painting influenced by large Cézanne retrospective of this year in Paris.
Worsening health: tuberculosis aggravated by hashish, ether, alcohol. Returned to Italy in autumn for several months.

1910 *The Cello Player*, exhibited at *Salon des Indépendants*, brought first recognition. Exhibited at *Indépendants* following year, and *Salon d'Automne*, 1912. Lived by sketching café portraits.

1914–1915 Met Leopold Zborowski, Polish poet who became friend and dealer; first sales to dealer, Paul Guillaume. Exhibited 1915 in private studio, 6 rue Huyhens. Gave up sculpture during first years of war.

1917 First one-man exhibition organized by Zborowski at Berthe Weill Gallery.

1918 Sojourn in South of France.

1919 Exhibited at *Salon d'Automne* and Hill Gallery, London.

1920 Died January 25, 1920.

Snapshot of the artist.
(The stone head was lent to the exhibition by Maurice Lefebvre-Foinet; see catalog page 53)

AMEDEO MODIGLIANI

Of facts pertaining to Modigliani's career, none is more singular than that he should have been so direct an heir to the Renaissance and Mannerist painters of his native Italy. He was separated from them by generations of artists, fluent and important at first, dwindling to cautious provincialism in the century preceding his own. Many of his immediate predecessors, beguiled by French Impressionism, had repudiated the linear eloquence — rigid or molten, equally assured — which is an earmark of the major Italian styles. Others, like Boldini, had mistaken recklessness for pride and others still, serious but weak, had tried to emulate Ingres' Neo-classic sobriety and awe. None of these men had the instinct for great drawing. Modigliani was to have it throughout his brief, tormented life.

Granting Modigliani's atavistic skill as a draftsman, the wonder is that it prospered amid a relatively alien climate. He left Italy for Paris in 1906, a year after the *Fauves* had brought to a climax their program to give color a dominant role. His maturity as a painter began when Cubism was emerging as the most vital movement in vanguard art; it was a movement that often reduced drawing to a shadow play within tinted screens. Of all his contemporaries in pre-1914 Paris, only De Chirico (significantly his countryman) seemed convinced that line might properly contain deep space as within a lariat. Few of the others could accept such a procedure; the majority dismissed it as an exhausted, illusionistic trick, violating the physical limitations of the painter's canvas. Cézanne's aim was still fresh in mind: "I try to render perspective solely by means of color."

For De Chirico's lonely repudiation of the newer trends in Parisian art, however, Modigliani substituted an eager acceptance of his colleagues' enthusiasms — Cézanne's distortions, the wedge-like contours of African

sculpture, Cubism's elisions and austerity. And while De Chirico was at that time primarily a painter of imaginative architecture, Modigliani's passion was for the human face and figure. We know now that he tried his hand once or twice at landscape. His hand alone was in these attempts, and there is no evidence that still life, the preferred theme of the Cubists, ever interested him seriously. He really loved only human subjects: the head, the full figure, nearly always presented singly, the very antithesis of Cézanne's late compositions wherein multiple human forms become elements of masonry, opposing or supporting each other to create a majestic nave. In his intensity of individual characterization, Modigliani holds a fairly solitary place in his epoch. One senses in his finest pictures a unique and forceful impact from the sitter, an atmosphere of special circumstance, not to recur. But he was far from being simply a realist. On the contrary, he solved repeatedly one of modern portraiture's most difficult problems: how to express objective truth in terms of the artist's private compulsion. The vigor of his style burns away over-localized fact. Indeed, his figures at times have the fascination of ventriloquists' dummies. They are believable and wholly in character, yet they would be limp and unimaginable without his guiding animation.

Taken as a whole, though each is idiosyncratic, Modigliani's portraits constitute the gallery of an era and of a world, the last real Bohemia, before artists were obliged to share their favorite purlieus with a public envious of their license and gaiety. Painters, poets, musicians, eccentrics, svelte mistresses, servants, tradesmen, adolescents — these form the cast of Modigliani's drama; they were all of them friends. His energy in assembling them was astounding. He raged through the streets at night, drunk and fatally ill, hailing friends and berating strangers, moving from café to café, affectionate, troublesome, the asceticism of Italy and ancient Jewry in his marvelous face. And always penniless. Friends tried to help him, of course, but often they were as destitute as he, and in any case he could not rest or be saved. Like Masaccio, Giorgione, Caravaggio, Watteau, Géricault, like all those brilliant artists whose early deaths haunt the beginnings of centuries, Modigliani was doomed and perfectly aware of it. His struggle was to keep going long enough to produce his work, as much as possible. And produce he did, despite drink, drugs and a sensuality which drove him from one love affair to another. Tattered, cold, trembling, frightened of his deadly cough, he somehow managed to paint steadily, relishing his models as company and as challenge. He drew constantly, everywhere and at all hours; he seems never to have stopped drawing for long. It is idle to argue that he might have been a more profound artist had he nursed his energies. Exacerbated nerves were part of his talent's high price.

Modigliani was not a congenital revolutionary like Picasso and the

10

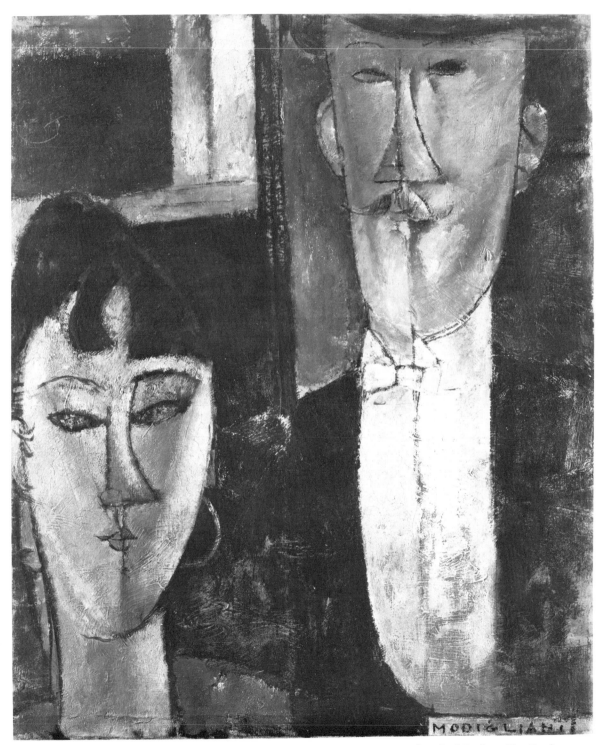

Bride and Groom. 1915. Oil, 21¾ x 18¼″. The Museum of Modern Art, New York, gift of Frederic Clay Bartlett

young Matisse. He was essentially a traditionalist who happened to have caught fire from the excitement of a contemporary idiom. Once he had discovered his style, once he had fought clear of *fin de siècle* artifice and the rival weight of Impressionism, he held to his road. Usually he preferred rusted colors, Mannerist elongations and those wry dislocations of his subjects' features — see-saw eyes and pendulous noses, oval heads on tubular necks — which are so unmistakably his own. He did not need or want to change, and he had no time. But within his admittedly narrow range, he showed a remarkable sensitivity to evocative detail. He conveyed much, for example, through the placing of a model's arms, heavy with embarrassment, or easy and forgotten, weak or bold, the hands often clasped in a foreground arc. In certain portraits the eyes are a dusty jade, open wide; in others, lidded and evasive; in others still, sharp as beads within a surrounding flaccidity. The small, pursed mouth was a favorite device, but he varied it to suggest changing shades of character and mood. It is chiefly because all the portraits look so forcefully his that we tend to think them all the same. They are not, as the careful observer will know.

Modigliani's most ambitious paintings are his nudes — those images of women lying naked, aggressive and pleased, the tension of frank moment

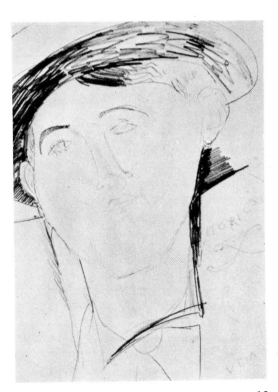

Conrad Moricand. c. 1916. Pencil, 12 x 9″.
Collection Mr. and Mrs. Leon Brillouin,
New York

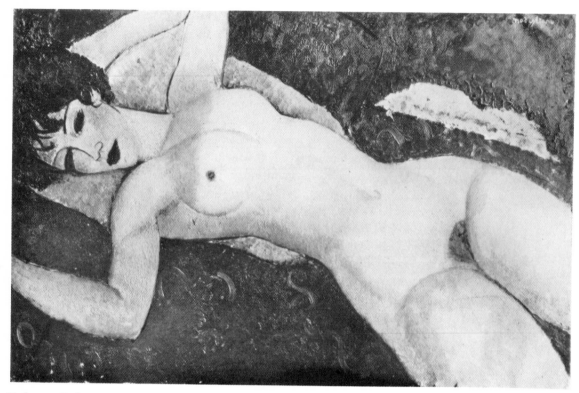

Nude on a Cushion. 1917-18. Oil, 23½ x 36¼". Collection Gianni Mattioli, Milan

in their faces and animal pride. They are in fact the nudest of nudes, the absolute contradiction of Redon's dictum: "The painter who paints a nude woman, leaving in our mind the idea that she is going to dress herself immediately, is not an intellectual." One feels that Modigliani's models have flung off their clothes, eager for the artist's admiration and utterly unrestrained. These are (let us be candid) erotic nudes for the most part, though dignified by conviction of style. If we compare them with Manet's *Olympia,* so scandalous in its time, we see that the last vestiges of allegorical disguise have been abandoned; a Baudelairian atmosphere of sin has been replaced by blunt stress on precisely the physical realities that earlier art had usually moderated or concealed. Modigliani's women are not the grown-up cherubs of which the eighteenth century was fond. They are adult, sinuous, carnal and real, the final stage in the sequence leading from Giorgione's *Concert Champêtre* to Manet's *Déjeuner Sur*

14

l'Herbe and on to Lautrec and his contemporaries. Yet whereas a certain picturesqueness of evil attaches to Lautrec's works, and indeed to those of many modern artists from Rops to Pascin, Modigliani's sensuality is clear and delighted, like that of Ingres but less afraid. His nudes are an emphatic answer to his Futurist countrymen who, infatuated with the machine, considered the subject outworn and urged its suppression for a period of ten years.

Like many painters who have been decisive draftsmen, Modigliani was attracted by the problems of sculpture, and his work in this medium, though sometimes too insistently archaic, is at its best a considerable achievement. His interest in sculpture was apparently encouraged by Brancusi, and from that master, perhaps, he first absorbed the ubiquitous Parisian admiration for the sculptures of very ancient or very primitive peoples. The tribal arts of Africa were to remain a principal influence on him, and Egypt's stylized grandeur had a marked effect. But Modigliani reacted as well to the Byzantine and Romanesque traditions, created before raw Christian authority in sculpture was modified by classical doubts. Whatever was fresh, powerful and innocent appealed to him, and only occasionally did he emulate these virtues instead of proposing them anew. In sculpture as in painting, his sole concern was the human face and figure, and this is true even of those works which seem intended for architectual use — the caryatid and the corbelled head. He dreamed once of working in Carrara's quarries; his instinct was for direct carving rather than modeling in plaster or clay. It may be that this technical preference, swollen to a purist dogma since his death, accounts in part for the nervous vitality of Modigliani's best pieces. They are at any rate exceptionally vigorous, and if we sometimes resent their exaggerations, we know they are alive.

If Modigliani himself had lived? He would be sixty-six now, younger than the men — Matisse, Rouault, Brancusi, Picasso, Braque — who continue to be the most persuasive figures in contemporary European art. He could not have held their pace, not only because his fever was integral with his gifts, as already suggested, but because the creative span of modern Italian painters is especially brief, as though the rich old age of Titian and the others had been borrowed in some sense from their living descendants. In any case there is enough of Modigliani's work, enough to guarantee him a lasting place, to assure us a pleasure that only true artists can give at all and few today with so deft a hand.

J. T. S.

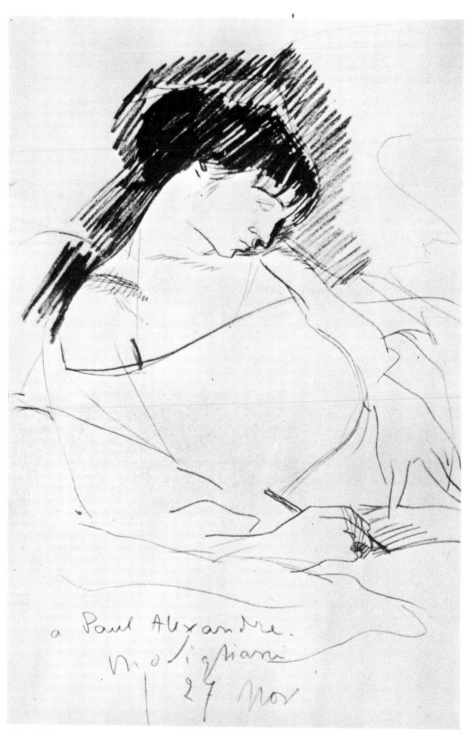

Maud Abrantes Writing in Bed. 1908. Pencil, 12¼ x 7⅞". Collection Dr. Paul Alexandre, Paris

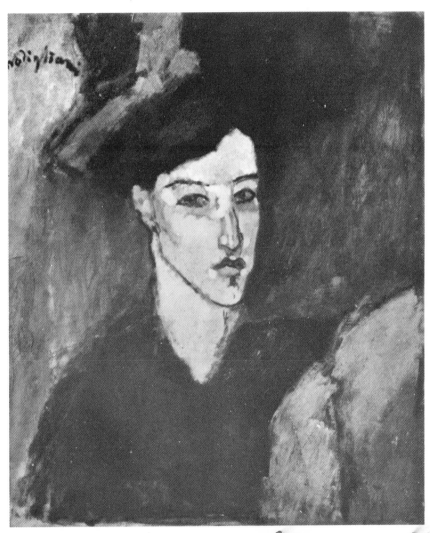

The Jewess. 1908. Oil, 21½ x 18″. Collection Dr. Paul Alexandre, Paris

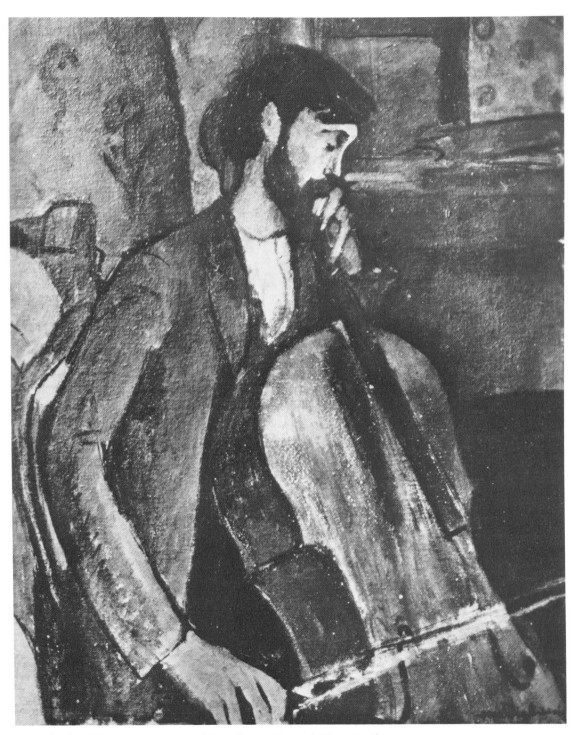

The Cellist (study). 1909. Oil, 29 x 23½". Collection Dr. Paul Alexandre, Paris

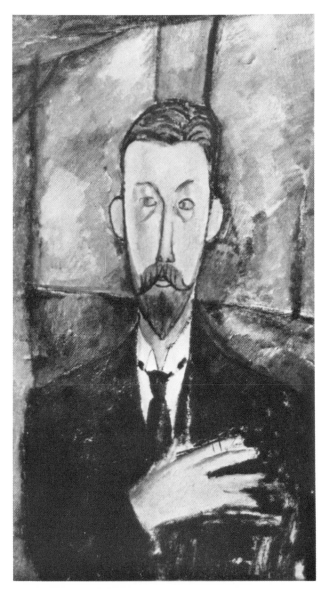

Dr. Paul Alexandre before a Window-pane. 1913.
Oil, 31½ x 15½". Collection Dr. Paul Alexandre, Paris

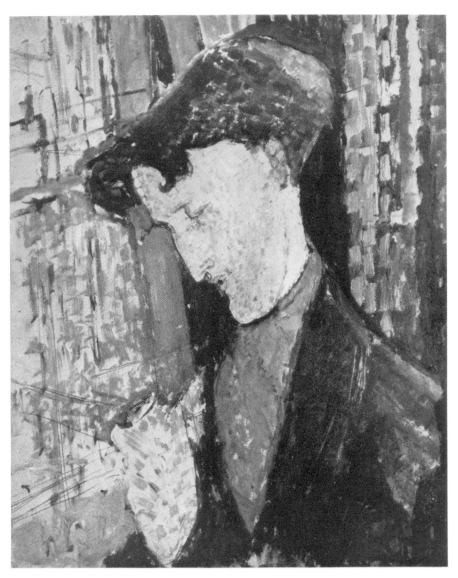

Frank Burty Haviland. c. 1914. Oil, 28¾ x 23⅝". Collection Gianni Mattioli, Milan

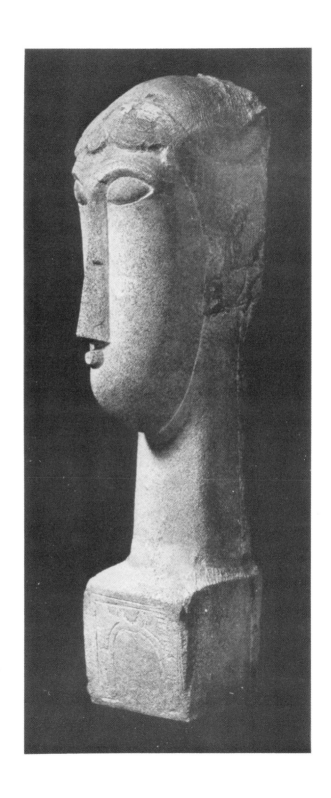

Head. Limestone, 27″ high.
The Philadelphia Museum of Art,
given by Mrs. Maurice J. Speiser
in memory of her husband

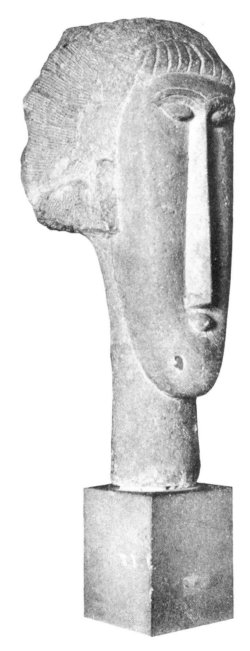

Head. Limestone, 25½″ high.
Chester Dale Collection,
Philadelphia Museum of Art

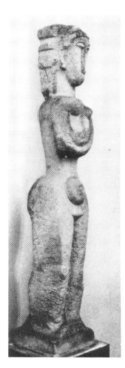
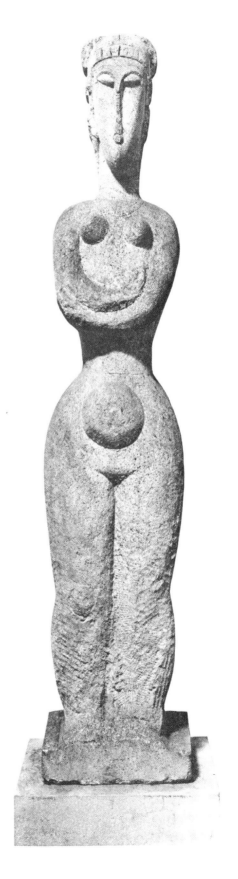

Figure. Limestone, 63" high.
Collection François Reichenbach, Paris

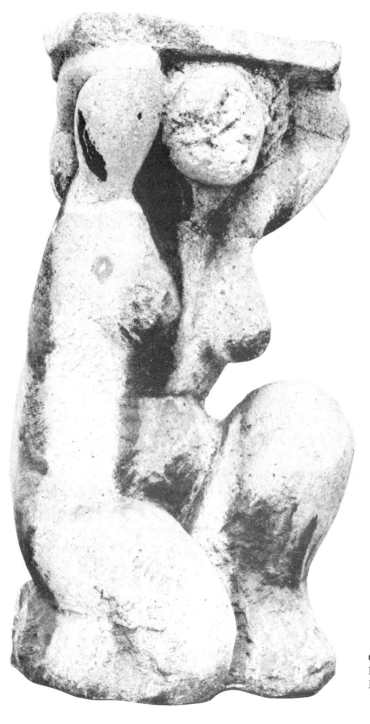

Caryatid. c. 1914.
Limestone, 36¼″ high.
Buchholz Gallery, New York

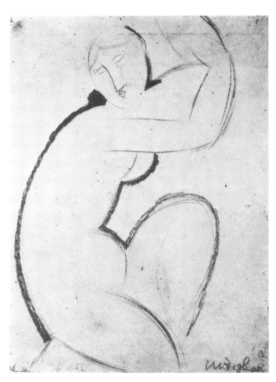

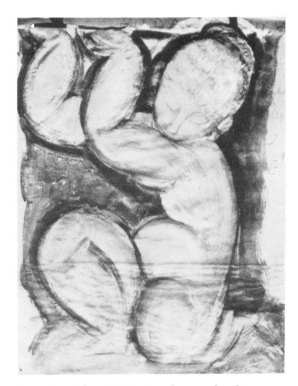

Caryatid (Crouching Nude). 1914? Pencil and crayon, 13½ x 10½". Chester Dale Collection, New York

Rose Caryatid. c. 1914. Gouache, pencil and crayon, 23¾ x 17¾". The Norton Gallery and School of Art, West Palm Beach

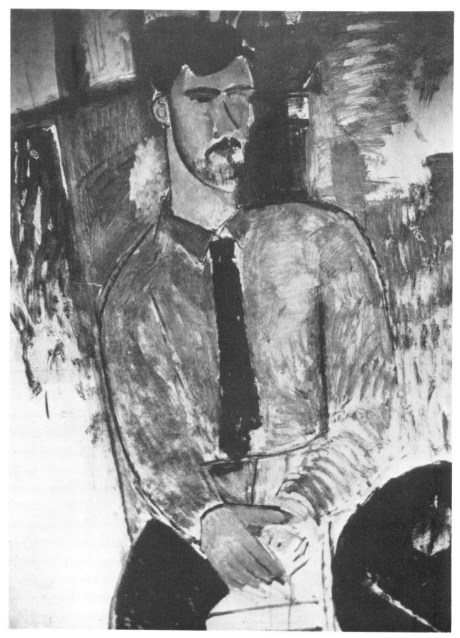

Henri Laurens. 1915. Oil, 31⅞ x 23⅝". Collection Luigi Corbellini, Paris

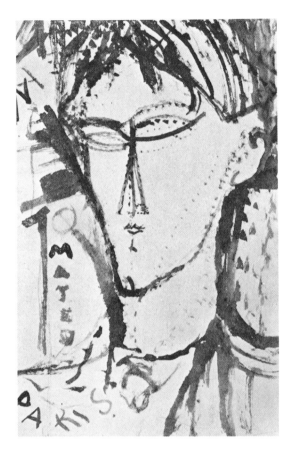

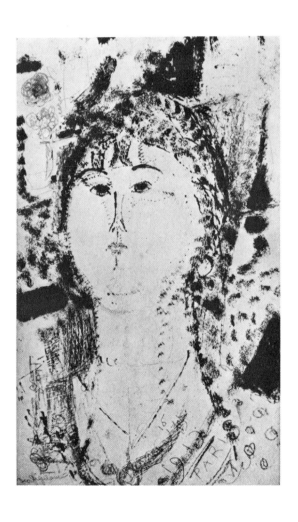

Mateo. 1915. Brush and ink wash, 19½ x 12¾".
Collection Henry Pearlman, New York

LEFT: *Woman's Head (Rosa Porprina)*. 1915.
Colored pencil and oil on paper, 17¼ x 10½".
Collection Dr. Riccardo Jucker, Milan

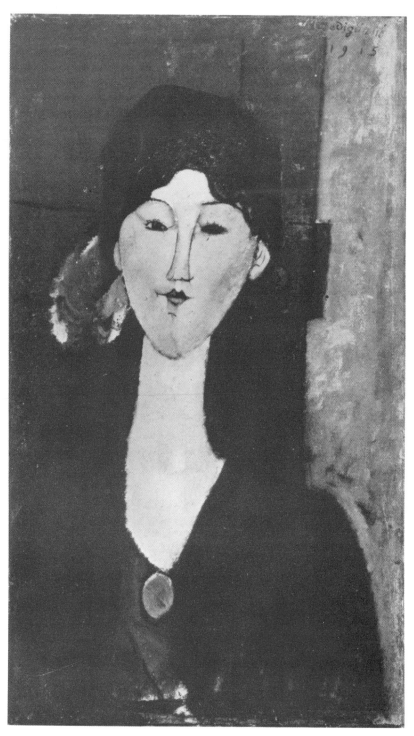

Beatrice Hastings. 1915. Oil, 31 x 18″. Collection Mr. and Mrs. Leon Brillouin, New York

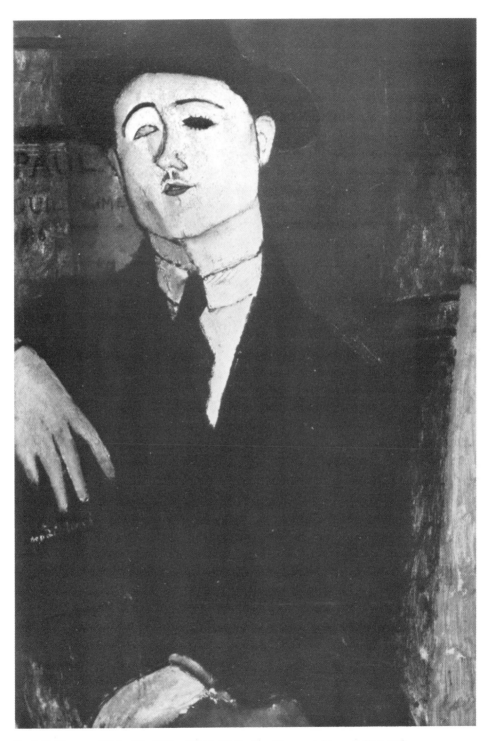

Paul Guillaume. 1916. Oil, 31½ x 21¼". Collection Comm. Adriano Pallini, Milan

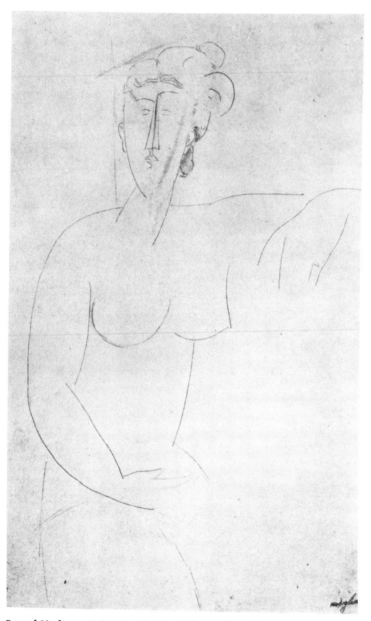

Seated Nude. c. 1916. Pencil, 17 x 10½". Perls Galleries, New York

OPPOSITE: *Anna Zborowska.* 1916. Oil, 32 x 19¾". Collection Mr. and Mrs. Alex L. Hillman, New York

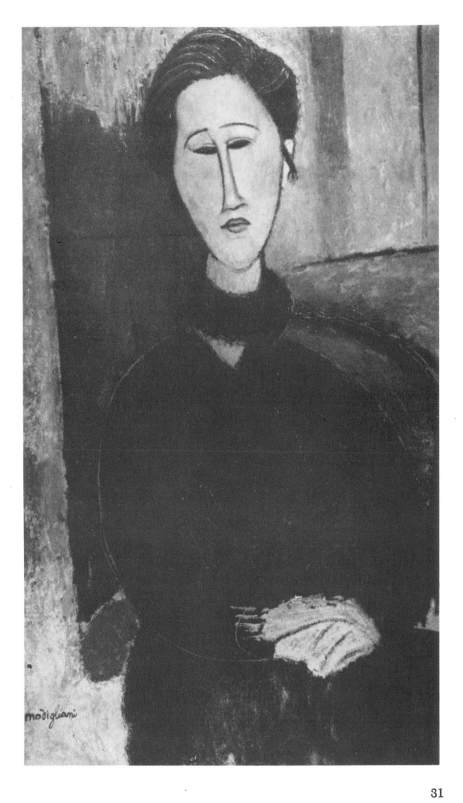

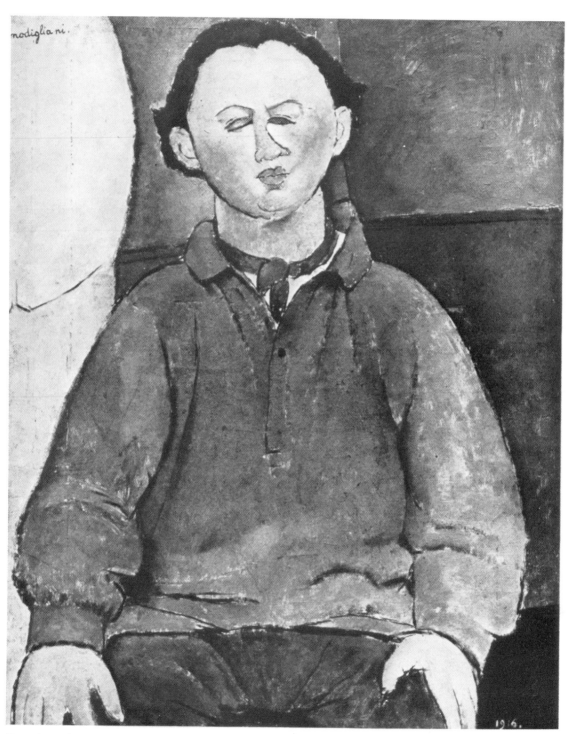

Oscar Miestchaninoff. 1916. Oil, 32 x 25½″. Collection César M. de Hauke, Paris

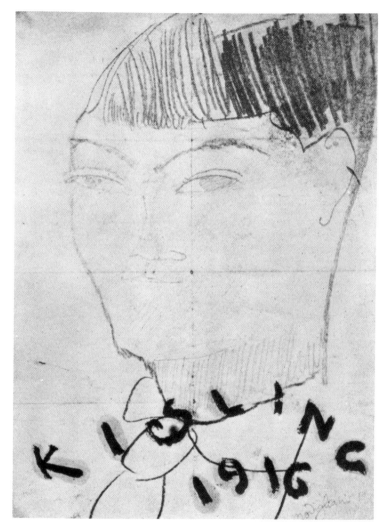

Head of Kisling. 1916. Wax crayon, 10⅝ x 8⅜″. Perls Galleries, New York

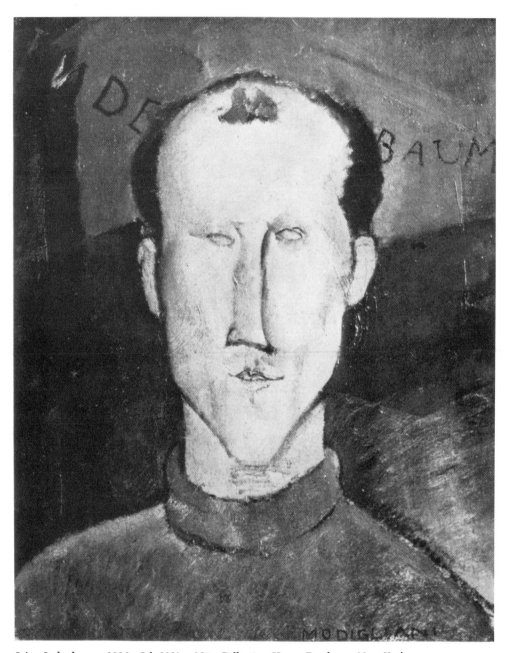

Léon Indenbaum. 1916. Oil, 21½ x 18″. Collection Henry Pearlman, New York

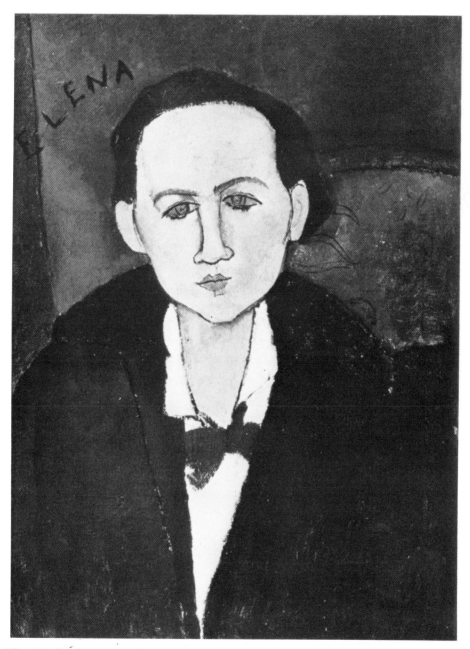

Elena Pawlowski. 1917. Oil, 25¼ x 19″. The Phillips Gallery, Washington, D.C.

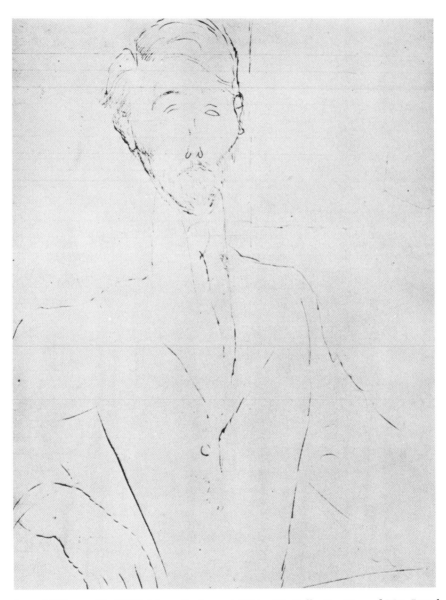

Leopold Zborowski. 1917? Ink on lined paper, 10½ x 8″. Collection Mr. and Mrs. Joseph Pulitzer, Jr., St. Louis

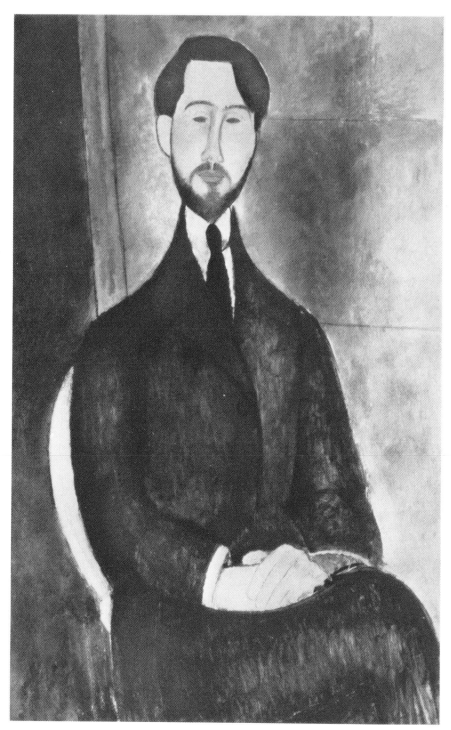

Leopold Zborowski. 1917. Oil, 42 x 26″. Museu de Arte, São Paulo, Brazil

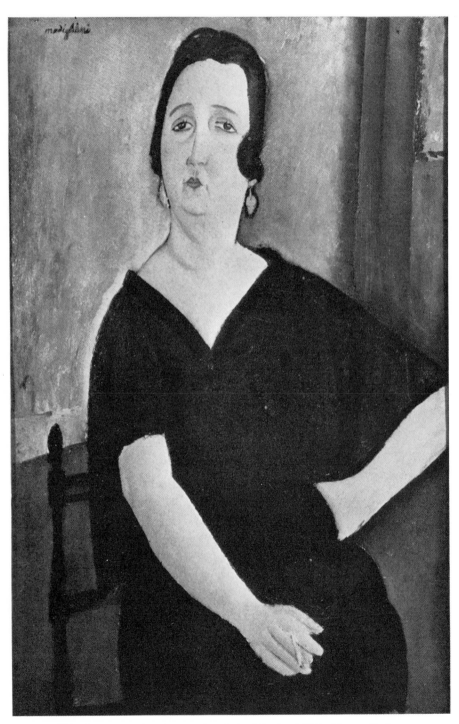

Mme Amédée (*Woman with a Cigarette*). 1918. Oil, 39 x 25¼". Chester Dale
Loan Collection, The Art Institute of Chicago

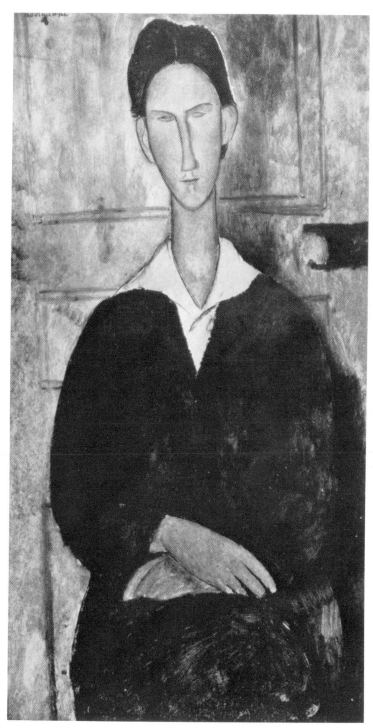

Boy with Red Hair. c. 1919. Oil, 38 x 25″. Collection Ralph M. Coe, Cleveland

Soutine in a Café. 1917? Pencil, 12¾ x 10″. Collection Jacques Sarlie, New York

OPPOSITE: *Soutine.* 1917. Oil, 36¼ x 23¼″.
Chester Dale Collection,
Philadelphia Museum of Art

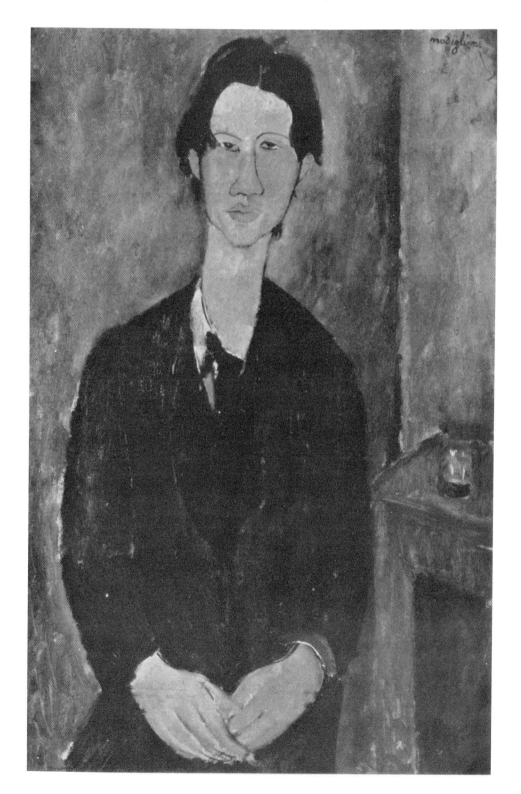

41

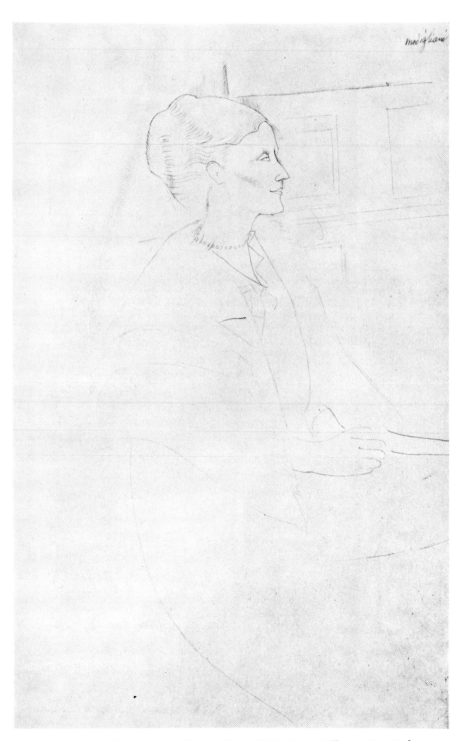

A Lady. 1919? Pencil, 16 x 10″. Collection Mr. and Mrs. Leon Brillouin, New York

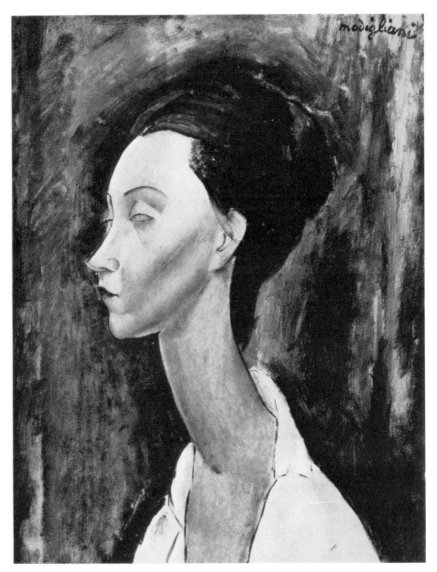

Lunia Czechowska. 1919. Oil, 18½ x 13″. Collection Carlo Frua de Angeli, Milan

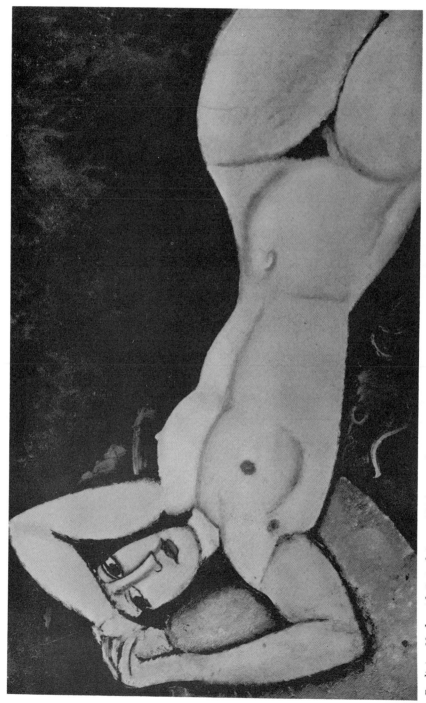

Reclining Nude with Raised Arms. 1917-18. Oil, 25½ x 39½". Collection Richard S. Zeisler, New York

COLOR PLATE: *Reclining Nude.* c. 1919. Oil, 28¾ x 45¾". The Museum of Modern Art, New York, Mrs. Simon Guggenheim Fund

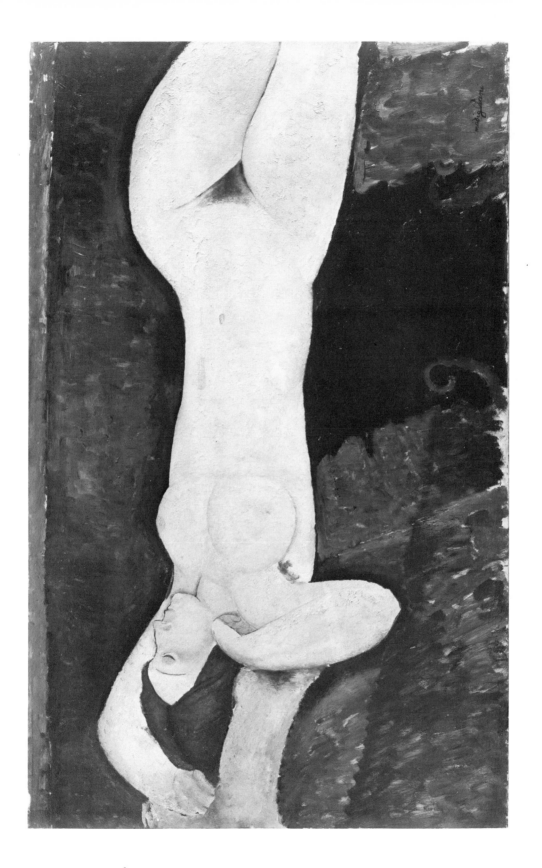

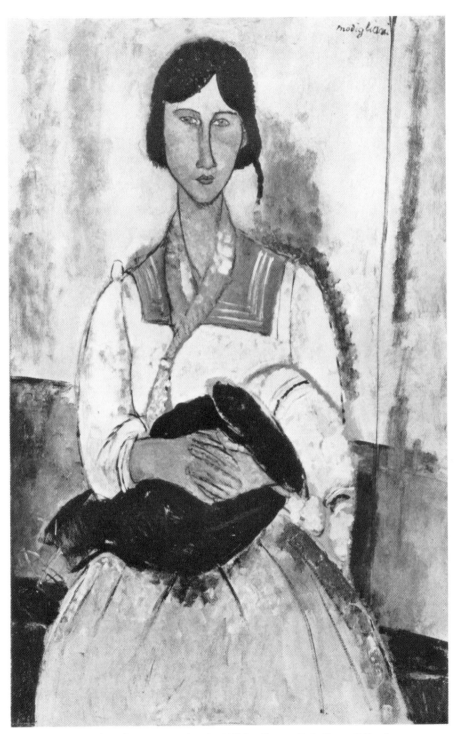

Gypsy Woman with Baby. 1919. Oil, 45 x 28¾". Chester Dale Loan Collection, Art Institute of Chicago

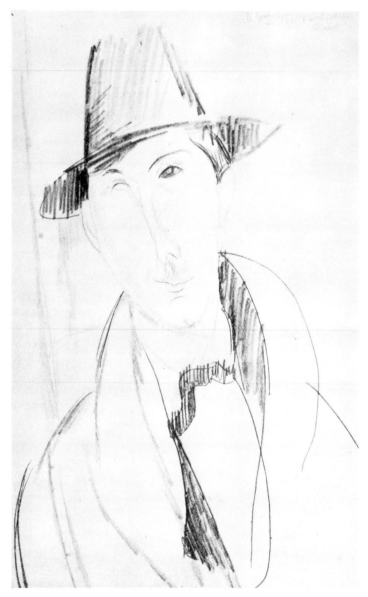

Man with a Hat (Portrait of Mario). 1920. Pencil, 19¼ x 12″. The Museum of Modern Art, New York

OPPOSITE: *Self-portrait*. 1919. Oil, 33½ x 23½″. Collection Mr. and Mrs. Francisco Matarazzo Sobrinho, São Paulo, Brazil

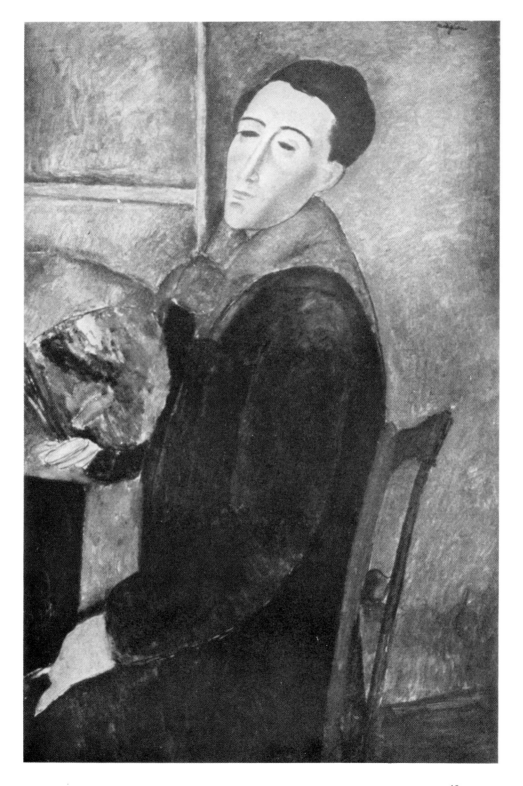

49

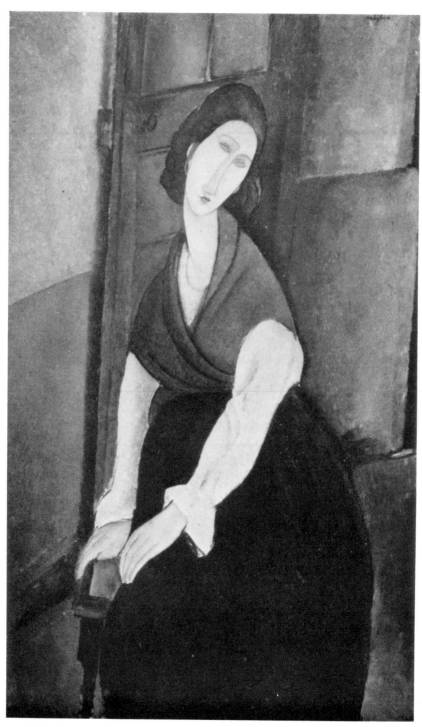

Jeanne Hebuterne. 1919. Oil, 51 x 32″. Collection Mr. and Mrs. Leon Brillouin, New York

CATALOG OF THE EXHIBITION

Exhibition dates: Cleveland, January 30 to March 18, 1951; New York, April 11 to June 10, 1951

An asterisk (°) preceding the catalog entry indicates that the painting is illustrated. In listing the dimensions, height precedes width. In general dating follows that of Pfannstiel (bibl. 6).

PAINTINGS

°*The Jewess.* 1908. Oil, 21½ x 18″. Lent by Dr. Paul Alexandre, Paris. *Ill. p. 17*

Maud Abrantes. 1908. Oil, 23½ x 19¾″. Lent by Dr. Paul Alexandre, Paris

°*The Cellist* (study). 1909. Oil, 29 x 23½″. (Oil sketch of the sculptor Brancusi on reverse of canvas). Lent by Dr. Paul Alexandre, Paris. *Ill. p. 18*

The Beggar of Leghorn. 1909. Oil, 26 x 23¼″. Lent by Dr. Paul Alexandre, Paris

Dr. Paul Alexandre (*Dandy*). 1911. Oil, 36¼ x 24″. Lent by Dr. Paul Alexandre, Paris

°*Dr. Paul Alexandre before a Window-pane.* 1913. Oil, 31½ x 15½″. Lent by Dr. Paul Alexandre, Paris. *Ill. p. 19*

°*Frank Burty Haviland.* c. 1914. Oil, 28¾ x 23⅝″. Lent by Gianni Mattioli, Milan. *Ill. p. 20*

°*Henri Laurens.* 1915. Oil, 31⅞ x 23⅝″. Lent by Luigi Corbellini, Paris. *Ill. p. 26*

Portrait of a Man. c. 1915. Oil, 21 x 16½″. Lent by Mr. and Mrs. Joseph Bissett, New York

The Little Gypsy. 1915. Oil, 31½ x 21½″. Lent by the Earl of Sandwich, Hinchingbrooke, England

Marie Vasilieff. 1915? Oil, 28¾ x 20½″. Lent by M. Zagajski, New York

Madam[e] Pompadour. 1915 (dated). Oil, 23⅞ x 19½″. The Art Institute of Chicago, Joseph Winterbotham Collection

°*Beatrice Hastings* (*Femme au Pendentif*). 1915 (dated). Oil, 31 x 18″. Lent by Mr. and Mrs. Leon Brillouin, New York. *Ill. p. 28*

°*Bride and Groom.* 1915. Oil, 21¾ x 18¼″. The Museum of Modern Art, New York, gift of Frederic Clay Bartlett. *Ill. in color, p. 11*

°*Paul Guillaume.* 1916 (dated). Oil, 31½ x 21¼″. Lent by Comm. Adriano Pallini, Milan. *Ill. p. 29*

°*Anna Zborowska.* 1916. Oil, 32 x 19¾″. Lent by Mr. and Mrs. Alex L. Hillman, New York. *Ill. p. 31*

°*Oscar Miestchaninoff.* 1916 (dated). Oil, 32 x 25½″. Lent by César M. de Hauke, Paris. *Ill. p. 32*

°*Léon Indenbaum.* 1916. Oil, 21½ x 18″. Lent by Henry Pearlman, New York. *Ill. p. 34*

Jacques Lipchitz and his Wife. 1916-17. Oil, 31½ x 21″. The Art Institute of Chicago, Helen Birch Bartlett Memorial Collection

Blaise Cendrars. 1917. Oil, 23¾ x 19⅝″. Lent anonymously.

°*Elena Pawlowski.* 1917. Oil, 25¼ x 19″. Lent by The Phillips Gallery, Washington, D. C. *Ill. p. 35*

Girl with Braids (*The Pink Blouse*). 1917. Oil, 23½ x 17½″. Lent by Mr. and Mrs. Sam A. Lewisohn, New York

Jean Cocteau. 1917. Oil, 39½ x 32″. Lent by the Estate of George Gard DeSylva, through the courtesy of the Los Angeles County Museum.

Anna Zborowska. 1917. Oil, 50½ x 31½″. The Museum of Modern Art, New York, Lillie P. Bliss Collection

Adrienne (*Woman with Bangs*). 1917. Oil, 21½ x 15″. Chester Dale Loan Collection, The Art Institute of Chicago

°*Soutine.* 1917. Oil, 36¼ x 23¼″. Chester Dale Collection, The Philadelphia Museum of Art. *Ill. p. 41*

The Flower Vendor. 1917. Oil, 45¾ x 28⅜.″ Lent by Mr. and Mrs. Samuel A. Marx, Chicago.

Dr. Devaraigne. 1917 (dated). Oil, 21¾ x 18″. Lent by Mrs. John W. Garrett, Baltimore

The Little Servant Girl. 1917? Oil, 36¼ x 21¼″. Lent by Miss Fanny Brice, through the courtesy of Dalzell Hatfield, Los Angeles

Leopold Zborowski. 1917. Oil, 42 x 26″. Lent by the Museu de Arte, São Paulo, Brazil. *Ill. p. 37*

Paulette Jourdain. 1917 or 1919. Oil, 39½ x 25½″. Lent by M. L. Hermanos, New York

Nude with Coral Necklace. 1917. Oil, 25½ x 39¾″. Lent by Mr. and Mrs. Joseph Bissett, New York

Reclining Nude with Raised Arms. 1917-18. Oil, 25½ x 39½″. Lent by Richard S. Zeisler, New York. *Ill. p. 44*

Nude on a Cushion. 1917-18. Oil, 23½ x 36¼″. Lent by Gianni Mattioli, Milan. *Ill. p. 14*

Lunia Czechowska (The White Blouse). 1917-18. Oil, 28 x 17¼″. Lent by Mr. and Mrs. Sydney M. Shoenberg, Jr., St. Louis

Gaston Modot. 1918. Oil, 36¼ x 21¼″. Lent by Mrs. Lloyd Bruce Wescott, Clinton, N.J.

The Wife of the Artist (Jeanne Hebuterne). Nice, 1918. Oil, 39½ x 25½″. Lent by Mr. and Mrs. Bernard J. Reis, New York

Boy in a Blue Vest. 1918. Oil, 36½ x 24½″. Lent by the Pre-non-objective Collection of The Solomon R. Guggenheim Foundation, New York

The Zouave. 1918. 24¼ x 18″. Lent by Mr. and Mrs. Edward G. Robinson, Beverly Hills

Mme Amédée (Woman with a Cigarette). 1918. Oil, 39 x 25¼″. Chester Dale Loan Collection, The Art Institute of Chicago. *Ill. p. 38*

Seated Nude. 1918. Oil, 32½ x 26⅜″. Lent by Mr. and Mrs. Leigh B. Block, Chicago

Anna Zborowska. 1918. Oil, 16 x 9¼″. Lent by Dr. Stephen Goodyear, Englewood, N.J.

The Servant Girl (Marie Feret). 1918. Oil, 60 x 24″. Albright Art Gallery, Buffalo, Room of Contemporary Art

Lunia Czechowska. 1919. Oil, 18½ x 13″. Lent by Carlo Frua de Angeli, Milan. *Ill. p. 43*

Boy with Red Hair. c. 1919. Oil, 38 x 25″. Lent by Ralph M. Coe, Cleveland. *Ill. p. 39*

Elvira. 1919. Oil, 36 x 23¼″. Lent by Mr. and Mrs. Joseph Pulitzer, Jr., St. Louis

Peasant Girl. 1919. Oil, 24 x 18⅛″. Lent by Miss Marion G. Hendrie, Cincinnati

Gypsy Woman with Baby. 1919. Oil, 45 x 28¾″. Chester Dale Loan Collection, The Art Institute of Chicago. *Ill. p. 47*

Reclining Nude. c. 1919. Oil, 28¾ x 45¾″. The Museum of Modern Art, New York, Mrs. Simon Guggenheim Fund. *Ill. in color, p. 45*

Self-portrait. 1919. Oil, 33½ x 23½″. Lent by Mr. and Mrs. Francisco Matarazzo Sobrinho, São Paulo, Brazil. *Ill. p. 49*

Jeanne Hebuterne. 1919. Oil, 51 x 32″. Lent by Mr. and Mrs. Leon Brillouin, New York. *Ill. p. 50*

DRAWINGS, WATER COLORS, PASTELS

Head of a Woman. Early 1908. Watercolor, 18¾ x 12¼″. Lent by Dr. Paul Alexandre, Paris

Maud Abrantes Writing in Bed. Late 1908. Pencil, 12¼ x 7⅞″. Lent by Dr. Paul Alexandre, Paris. *Ill. p. 16*

Maud Abrantes. Late 1908. Watercolor, 16⅛ x 12½″. Lent by Dr. Paul Alexandre, Paris

The Cellist (study for oil). Late 1909. Ink, 10⅝ x 8⅛″. Lent by Dr. Paul Alexandre, Paris

The Sculptor Brancusi in an Armchair (study for oil on the reverse of *The Cellist*). 1910. Chinese ink, 15⅛ x 10½″. Lent by Dr. Paul Alexandre, Paris

Modigliani, Bearded (self-portrait). 1911. 17 x 10½″. Lent by Dr. Paul Alexandre, Paris

Hermaphrodite. 1912. Black crayon. Lent by Dr. Paul Alexandre, Paris

Crouching Female Nude. 1912. Black crayon, 16⅞ x 10½″. Lent by Dr. Paul Alexandre, Paris

Venus. 1913. Violet pencil, 16¾ x 10⅜″. Lent by Dr. Paul Alexandre, Paris

Dr. Paul Alexandre before a Window-pane (study for oil). October 31, 1913. Violet pencil, 17¼ x 10⅝″ (corrected with pasted paper). Lent by Dr. Paul Alexandre, Paris

Mask. 1913-15? Pencil and crayon, 16 x 9¾″. Lent by Mrs. Marjorie Fischer, New York

Head. 1914? Pastel, 15 x 11″. Lent by Ernest S. Heller, New York

Rose Caryatid. c. 1914. Gouache, pencil and crayon, 23¾ x 17¾″. Lent by the Norton Gallery and School of Art, West Palm Beach. *Ill. p. 25*

Green Caryatid. c. 1914. Gouache, 29¾ x 16¾″. Lent by the Perls Galleries, New York

Caryatid (Crouching Nude). 1914? Pencil and crayon, 13½ x 10½″. The Chester Dale Collection, New York. *Ill. p. 25*

Seated Figure of a Woman. 1914 or 1915. Pencil, 21¼ x 17". Lent by Dr. Alberto Rossi, Milan

°*Woman's Head (Rosa Porprina).* 1915 (dated). Colored pencil and oil on paper, 17¼ x 10½". Lent by Dr. Riccardo Jucker, Milan. *Ill. p. 27*

°*Mateo.* 1915. Brush and ink wash, 19½ x 12¾". Lent by Henry Pearlman, New York. *Ill. p. 27*

Woman's Head (Beatrice Hastings). 1915. Watercolor and pencil, 17⅛ x 10½". Lent by Miss Doris Baker, New York

Head of a Man. 1915. Oil on paper, 16 x 10". Lent by Benjamin Weiss, New York

°*Portrait of a Woman.* 1915. Pencil, 15⅜ x 9⅞". Lent by Mrs. Paul H. Sampliner, New York. *Frontispiece*

°*Seated Nude.* c. 1916. Pencil, 17 x 10½". Lent by the Perls Galleries, New York. *Ill. p. 30*

Two Girls at Prayers. c. 1916. Pencil, 16 x 10". Lent by Mr. and Mrs. Leon Brillouin, New York

The Young Pilgrim. c. 1916. Pencil, 18⅜ x 12¼". Lent by the Perls Galleries, New York

°*Head of Kisling.* 1916 (dated). Wax crayon, 10⅝ x 8⅜". Lent by the Perls Galleries, New York. *Ill. p. 33*

Moise Kisling. c. 1916. Pencil and wax crayon, 13½ x 9¾". Lent by Benjamin Weiss, New York

Seated Woman. c. 1916. Blue crayon, 27 x 21". Lent by Prince and Princess Artchil Gourielli, New York

°*Conrad Moricand.* c. 1916. Pencil, 12 x 9". Lent by Mr. and Mrs. Leon Brillouin, New York. *Ill. p. 13*

Leon Bakst. January 17, 1917 (dated). Pencil, 22½ x 16½". Lent by the Wadsworth Atheneum, Hartford

Portrait of a Boy. 1917. Pencil, 18 x 11⅜". Lent by Ralph M. Coe, Cleveland

Jean Cocteau. 1917? Pencil, 17 x 10½". Lent by Mrs. Towar Bullard, New York

Leopold Zborowski. 1917. Pencil, 18¾ x 12⅜". Lent by the Museum of Art, Rhode Island School of Design, Providence

Anna Zborowska. June 27, 1917 (dated). Pencil, 19⅜ x 12½". Lent by the Museum of Art, Rhode Island School of Design, Providence

°*Leopold Zborowski.* 1917? Ink on lined paper, 10½ x 8". Lent by Mr. and Mrs. Joseph Pulitzer, Jr., St. Louis. *Ill. p. 36*

The Pink Blouse. 1917. Pastel 13½ x 10". Lent by Mr. and Mrs. John Gerald, New York

°*Soutine in a Café.* 1917? Pencil, 12¾ x 10". Lent by Jacques Sarlie, New York. *Ill. p. 40*

Portrait of a Woman. 1918. Pencil, 16½ x 9½". Lent by Mrs. Marjorie Fischer, New York

Seated Nude. c. 1918. Pencil, 17⅞ x 12". Lent by Mrs. Marjorie Fischer, New York

Boy with Feathered Hat. c. 1918. Pencil, 14 x 9¼". Lent by Dr. and Mrs. Warner Muensterberger, New York

°*A Lady.* 1919? Pencil, 16 x 10". Lent by Mr. and Mrs. Leon Brillouin, New York. *Ill. p. 42*

Portrait of a Young Woman. 1919? Pencil, 11⅛ x 7⅜". Lent by the Fogg Art Museum (Paul J. Sachs Collection), Harvard University, Cambridge

Portrait of a Woman. 1919-20. Pencil, 19⅜ x 11⅞". The Museum of Modern Art, New York, given anonymously

°*Man with a Hat (Portrait of Mario).* 1920. Pencil, 19¼ x 12". The Museum of Modern Art, New York, given anonymously. *Ill. p. 48*

SCULPTURE

°*Head.* Limestone, 25½" high. Chester Dale Collection, The Philadelphia Museum of Art. *Ill. p. 22*

Head. Limestone, 26" high. Lent by Mr. and Mrs. Joseph Pulitzer, Jr., St. Louis

Head. Limestone, 22¼" high. The Museum of Modern Art, New York, gift of Mrs. John D. Rockefeller, Jr. in memory of Mrs. Cornelius J. Sullivan

°*Figure.* Limestone, 63". Lent by François Reichenbach, Paris. *Ill. p. 23*

°*Head.* Limestone, 27" high. The Philadelphia Museum of Art, given by Mrs. Maurice J. Speiser in memory of her husband. *Ill. p. 21*

°*Caryatid.* c. 1914. Limestone, 36¼" high. Lent by the Buchholz Gallery, New York. *Ill. p. 24*

Head. Stone, 20" high. Lent by Maurice Lefebvre-Foinet, Paris

Death Mask of Amedeo Modigliani, executed by Moise Kisling, Jacques Lipchitz and Conrad Moricand, January, 1920. Bronze, 9¼ x 6 x 4½". Chester Dale Collection, New York

SELECTED BIBLIOGRAPHY

Compiled by Hannah B. Muller, *Assistant Librarian, The Museum of Modern Art, New York*

This is a basic list of references to readings and reproductions available in American libraries. For additional material, the bibliographies mentioned below, especially that of Scheiwiller (bibl. 10) should be consulted.

MONOGRAPHS

1 BASLER, ADOLPHE. Modigliani. 16 pp. plus 32 plates Paris, Crès, 1931.
> Includes brief bibliography. Text also appeared in Le Crapouillot (Paris) Aug. 1927; in Paris-Montparnasse no. 13:7-11 Feb. 1930; and, in German, in Kunst und Künstler (Berlin) 28:355-63 June 1930.

2 CARRIERI, RAFFAELE. 12 opere di Amedeo Modigliani. 15 pp. illus. plus 12 col. plates Milano, Edizioni del Milione, 1947.

3 DALE, MAUD. Modigliani. 14 pp. plus 52 plates New York, A. A. Knopf, 1929.
> Reprinted, in part, in Formes (New York) no. 18:122 Oct. 1931; as introduction to Demotte Gallery catalog of Modigliani exhibition, New York, 1931; and to Palais des Beaux Arts, Brussels, catalog, 1933.

4 FRANCHI, RAFFAELLO. Modigliani. 44 pp. illus. plus 52 plates (some col.) Firenze, Arnaud, 1946.
> Includes extensive bibliography.

5 NICHOLSON, BENEDICT. Modigliani, paintings. 7 pp. plus 16 col. plates London, Lindsay Drummond; Paris, Editions du Chêne, 1948.

6 PFANNSTIEL, ARTHUR. Modigliani. 199 pp. plus 142 plates (some col.) Paris, Marcel Seheur, 1929.
> Introduction (personal reminiscences) by Louis Latourettes. Includes listing of early exhibitions, bibliography, and "catalogue présumé".

7 SALMON, ANDRÉ. Modigliani, sa vie et son oeuvre. 22 pp. plus 50 plates Paris, Editions des Quatre Chemins, 1926.

8 SAN LAZZARO, G. DI. Modigliani, peintures. 8 pp. plus 16 col. plates Paris, Editions du Chêne, 1947.

9 SCHAUB-KOCH, EMILE. Modigliani. 60 pp. 2 illus. Paris, Lille, Mercure Universel, 1933.

10 SCHEIWILLER, GIOVANNI. Amedeo Modigliani. 5. ed. 23 pp. plus 33 plates Milano, Hoepli, 1950. (Arte moderna italiana. 8)
> Text dated 1925. First published 1927. Includes extensive bibliography. Translated into French with changes in text and plates and without bibliography, Paris, Editions des Chroniques du Jour, 1928. (Messages d'esthétique. 1) 16 pp. plus 23 plates.

11 VITALI, LAMBERTO. Disegni di Modigliani. 15 pp. illus. plus 32 plates Milano, Hoepli, 1929. (Arte moderna italiana)
> Includes bibliography.

REMINISCENCES BY MODIGLIANI'S FRIENDS

12 CARCO, FRANCIS. De Montmartre au quartier latin. p. 193-201, 240-47 Paris, Michel, 1927.

13 ――― L'ami des peintres. p37-47 Genève, Editions du Milieu du Monde, 1944.

14 COQUIOT, GUSTAVE. Des peintres maudits. p. 99-112 Paris, André Delpeuch, 1924.
> Includes reprint of text published in the author's Les indépendants. 4e éd. p. 98-99 Paris, Ollendorff, 1920. Translated into German in Kunst und Künstler (Berlin) 24:467-70 1926.

15 DOUGLAS, CHARLES. Artist quarter: reminiscences of Montmartre and Montparnasse. passim illus. London, Faber and Faber, 1941.

16 FELS, FLORENT. Modigliani. Der Querschnitt (Berlin) 6:522-25 July 1926, 5 illus.

17 JEDLICKA, GOTTHARD. Eine Modigliani-Anekdote. Deutsche Kunst und Dekoration (Darmstadt) 70:84-87 May 1932, 3 illus.

18 ――― Die letzten Jahre von Modigliani. Werk (Zurich) 34:25-36 Jan. 1947, 6 illus.
> Includes quotations of statements by Jacques Lipchitz.

19 MEIDNER, LUDWIG. Young Modigliani: some memories. Burlington Magazine (London) 82:87-91 Apr. 1943, 4 illus.
 Reprinted, with slight changes, from Das Kunstblatt (Berlin) 15:48-52 1931, 5 illus.

20 SACHS, MAURICE. Modigliani, the fated. Creative Art (New York) 10:98-103 Feb. 1932, 6 illus. (incl. ports.)

21 SALMON, ANDRÉ. Propos d'atelier. p. 217-22 Paris, Crès, 1922.
 Reprinted, with slight changes, from Amour de l'Art (Paris) 3:20-22 Jan. 1922, 3 illus.

22 ——— Le vagabond de Montparnasse: vie et mort du peintre Amedeo Modigliani. Oeuvres Libres (Paris) 212:191-264 Feb. 1939.

23 ——— Quelques instants d'Amedeo Modigliani. In the author's L'air de la Butte. p. 110-20 Paris, Editions de la Nouvelle France, 1945.

24 VLAMINCK, MAURICE DE. Souvenir de Modigliani. Art Vivant (Paris) 1:21 Nov. 1 1925, 4 illus., port.
 Reprinted in the author's Tournant dangereux. p. 215-17 Paris, Stock, 1929; and in Beaux Arts (Paris) 74:1,3 Jan. 3 1936.
——— See also bibl. 1, 6, 7, 9.

STYLISTIC ANALYSES AND
SUMMARY PRESENTATIONS

25 BRIELLE, ROGER. Modigliani. *In* René Huyghe, ed. Histoire de l'art contemporain; la peinture. p. 142-44, 8 illus. Paris, Alcan, 1935. Reprinted from Amour de l'Art (Paris) 14 no. 6:142-44 June 1933.
 Biographical note and bibliography by Germain Bazin: p. 148-49.

26 DORIVAL, BERNARD. Les étapes de la peinture contemporaine. 3:193-97 et passim Paris, Gallimard, 1946.

27 GEORGE, WALDEMAR. Modigliani. Amour de l'Art (Paris) 6:383-87 Oct. 1925, 14 illus.

28 HISTORY OF MODERN PAINTING FROM PICASSO TO SURREALISM. p. 32-37,200, 5 col. illus. Geneva, Skira, 1950.
 Includes chronology and bibliographical note.

29 NEUGASS, FRITZ. Modigliani. Amour de l'Art (Paris) 12:190-201 1931, 18 illus.
 Reprinted, for the most part, in Art et les Artistes (Paris) new series 28:330-35 July 1934, 6 illus.

30 SLOCOMBE, GEORGE. Rebels of art. p. 264-72, 2 illus. New York, Arts & Decoration Book Society, 1939.
——— See also monographs, introductions to exhibition catalogs, and exhibition reviews.

MAJOR RETROSPECTIVE EXHIBITIONS

1922 Paris. Feb. 7-21. Galerie Bernheim-jeune. 39 works. Catalog

1925 Paris. Oct. 24-Nov. 15. Galerie Bing. 36 works. Catalog

1929 New York. Oct. 21-Nov. 9. De Hauke. 37 works. Catalog

1930 Venice. 17th Biennale. 46 works. Catalog with note by Lionello Venturi

1931 New York. November. Demotte Galleries. 29 works. Catalog with introduction by Maud Dale

1933 Brussels. November. Palais des Beaux Arts. 149 works. Catalog with introduction by Maud Dale

1934 Basel. Jan. 7-Feb. 4. Kunsthalle. 128 works. Catalog with introduction by Charles-Albert Cingria

1938 London. Mar. 17-Apr. 9. Arthur Tooth. 56 works. Catalog

1945 Paris. June 1-15. Galerie Claude. 38 works. Catalog with text by Gaston Diehl

1945-1946 Paris. Dec. 21-Jan. 31. Galerie de France. 41 works. Catalog with text by André Warnod

1946 Milan. April-May. Casa della Cultura. 61 works. Organized by Associazione fra gli amatori e i cultori delle arti figurative contemporanee. Catalog with text by Lamberto Vitali

This book has been printed in December, 1950, for the Trustees of The Museum of Modern Art, New York by the John B. Watkins Co., New York. The color plates were printed by the John P. Smith Co., Rochester, New York. Designed by Edward L. Mills

Museum of Modern Art Publications in Reprint

Abstract Painting and Sculpture in America. 1951. Andrew Carnduff Ritchie

African Negro Art. 1935. James Johnson Sweeney

American Art of the 20's and 30's: Paintings by Nineteen Living Americans; Painting and Sculpture by Living Americans; Murals by American Painters and Photographers. 1929. Barr; Kirstein and Levy

American Folk Art: The Art of the Common Man in America, 1750-1900. 1932. Holger Cahill

American Painting and Sculpture: 1862-1932. 1932. Holger Cahill

American Realists and Magic Realists. 1943. Miller and Barr; Kirstein

American Sources of Modern Art. 1933. Holger Cahill

Americans 1942-1963; Six Group Exhibitions. 1942-1963. Dorothy C. Miller

Ancient Art of the Andes. 1954. Bennett and d'Harnoncourt

The Architecture of Bridges. 1949. Elizabeth B. Mock

The Architecture of Japan. 1955. Arthur Drexler

Art in Our Time; 10th Anniversary Exhibition. 1939.

Art Nouveau; Art and Design at the Turn of the Century. 1959. Selz and Constantine

Arts of the South Seas. 1946. Linton, Wingert, and d'Harnoncourt

Bauhaus: 1919-1928. 1938. Bayer, W. Gropius and I. Gropius

Britain at War. 1941. Eliot, Read, Carter and Dyer

Built in U.S.A.: 1932-1944; Post-War Architecture. 1944. Mock; Hitchcock and Drexler

Cézanne, Gauguin, Seurat, Van Gogh: First Loan Exhibition. 1929. Alfred H. Barr, Jr.

Marc Chagall. 1946. James Johnson Sweeney

Giorgio de Chirico. 1955. James Thrall Soby

Contemporary Painters. 1948. James Thrall Soby

Cubism and Abstract Art. 1936. Alfred H. Barr, Jr.

Salvador Dali. 1946. James Thrall Soby

James Ensor. 1951. Libby Tannenbaum

Max Ernst. 1961. William S. Lieberman

Fantastic Art, Dada, Surrealism. 1947. Barr; Hugnet

Feininger-Hartley. 1944. Schardt, Barr, and Wheeler

The Film Index: A Bibliography (Vol. 1, The Film as Art). 1941.

**Five American Sculptors: Alexander Calder; The Sculpture of John B.
 Flannagan; Gaston Lachaise; The Sculpture of Elie Nadelman; The
 Sculpture of Jacques Lipchitz.** 1935-1954. Sweeney; Miller, Zigrosser;
 Kirstein; Hope

**Five European Sculptors: Naum Gabo—Antoine Pevsner; Wilhelm Lehmbruck—
 Aristide Maillol; Henry Moore.** 1930-1948. Read, Olson, Chanin; Abbott;
 Sweeney

**Four American Painters: George Caleb Bingham; Winslow Homer, Albert P.
 Ryder, Thomas Eakins.** 1930-1935. Rogers, Musick, Pope; Mather, Burroughs,
 Goodrich

German Art of the Twentieth Century. 1957. Haftmann, Hentzen and Lieberman;
 Ritchie

Vincent van Gogh: A Monograph; A Bibliography. 1935, 1942. Barr; Brooks

Arshile Gorky. 1962. William C. Seitz

Hans Hofmann. 1963. William C. Seitz

Indian Art of the United States. 1941. Douglas and d'Harnoncourt

**Introductions to Modern Design: What is Modern Design?; What is
 Modern Interior Design?** 1950-1953. Edgar Kaufmann, Jr.

Paul Klee: Three Exhibitions: 1930; 1941; 1949. 1945-1949. Barr;
 J. Feininger, L. Feininger, Sweeney, Miller; Soby

Latin American Architecture Since 1945. 1955. Henry-Russell Hitchcock

Lautrec-Redon. 1931. Jere Abbott

Machine Art. 1934. Philip Johnson

John Marin. 1936. McBride, Hartley and Benson

Masters of Popular Painting. 1938. Cahill, Gauthier, Miller, Cassou, et al.

Matisse: His Art and His Public. 1951. Alfred H. Barr, Jr.

Joan Miró. 1941. James Johnson Sweeney

Modern Architecture in England. 1937. Hitchcock and Bauer

Modern Architecture: International Exhibition. 1932. Hitchcock, Johnson,
 Mumford; Barr

Modern German Painting and Sculpture. 1931. Alfred H. Barr, Jr.

Modigliani: Paintings, Drawings, Sculpture. 1951. James Thrall Soby

Claude Monet: Seasons and Moments. 1960. William C. Seitz

Edvard Munch; A Selection of His Prints From American Collections. 1957.
 William S. Lieberman

The New American Painting; As Shown in Eight European Countries, 1958-1959.
 1959. Alfred H. Barr, Jr.

New Horizons in American Art. 1936. Holger Cahill

New Images of Man. 1959. Selz; Tillich

Organic Design in Home Furnishings. 1941. Eliot F. Noyes

Picasso: Fifty Years of His Art. 1946. Alfred H. Barr, Jr.

Prehistoric Rock Pictures in Europe and Africa. 1937. Frobenius and Fox

Diego Rivera. 1931. Frances Flynn Paine

Romantic Painting in America. 1943. Soby and Miller

Medardo Rosso. 1963. Margaret Scolari Barr

Mark Rothko. 1961. Peter Selz

Georges Roualt: Paintings and Prints. 1947. James Thrall Soby

Henri Rousseau. 1946. Daniel Catton Rich

Sculpture of the Twentieth Century. 1952. Andrew Carnduff Ritchie

Soutine. 1950. Monroe Wheeler

Yves Tanguy. 1955. James Thrall Soby

Tchelitchew: Paintings, Drawings. 1942. James Thrall Soby

Textiles and Ornaments of India. 1956. Jayakar and Irwin; Wheeler

Three American Modernist Painters: Max Weber; Maurice Sterne; Stuart Davis. 1930-1945. Barr; Kallen; Sweeney

Three American Romantic Painters: Charles Burchfield: Early Watercolors; Florine Stettheimer; Franklin C. Watkins. 1930-1950. Barr; McBride; Ritchie

Three Painters of America: Charles Demuth; Charles Sheeler; Edward Hopper. 1933-1950. Ritchie; Williams; Barr and Burchfield

Twentieth-Century Italian Art. 1949. Soby and Barr

Twenty Centuries of Mexican Art. 1940

Edouard Vuillard. 1954. Andrew Carnduff Ritchie

The Bulletin of the Museum of Modern Art, 1933-1963. (7 vols.)

This reprinted edition was produced by the offset printing process. The text and plates were photographed separately from the original volume, and the plates rescreened. The paper and binding were selected to ensure the long life of this library grade edition.